The Coloring Experience: Relaxation for the Soul

by Rubina Syed

Email: designsbyRubina@gmail.com

Copyright © 2017 Rubina Syed

All rights reserved.

ISBN-10: 1544656041
ISBN-13: 978-1544656045

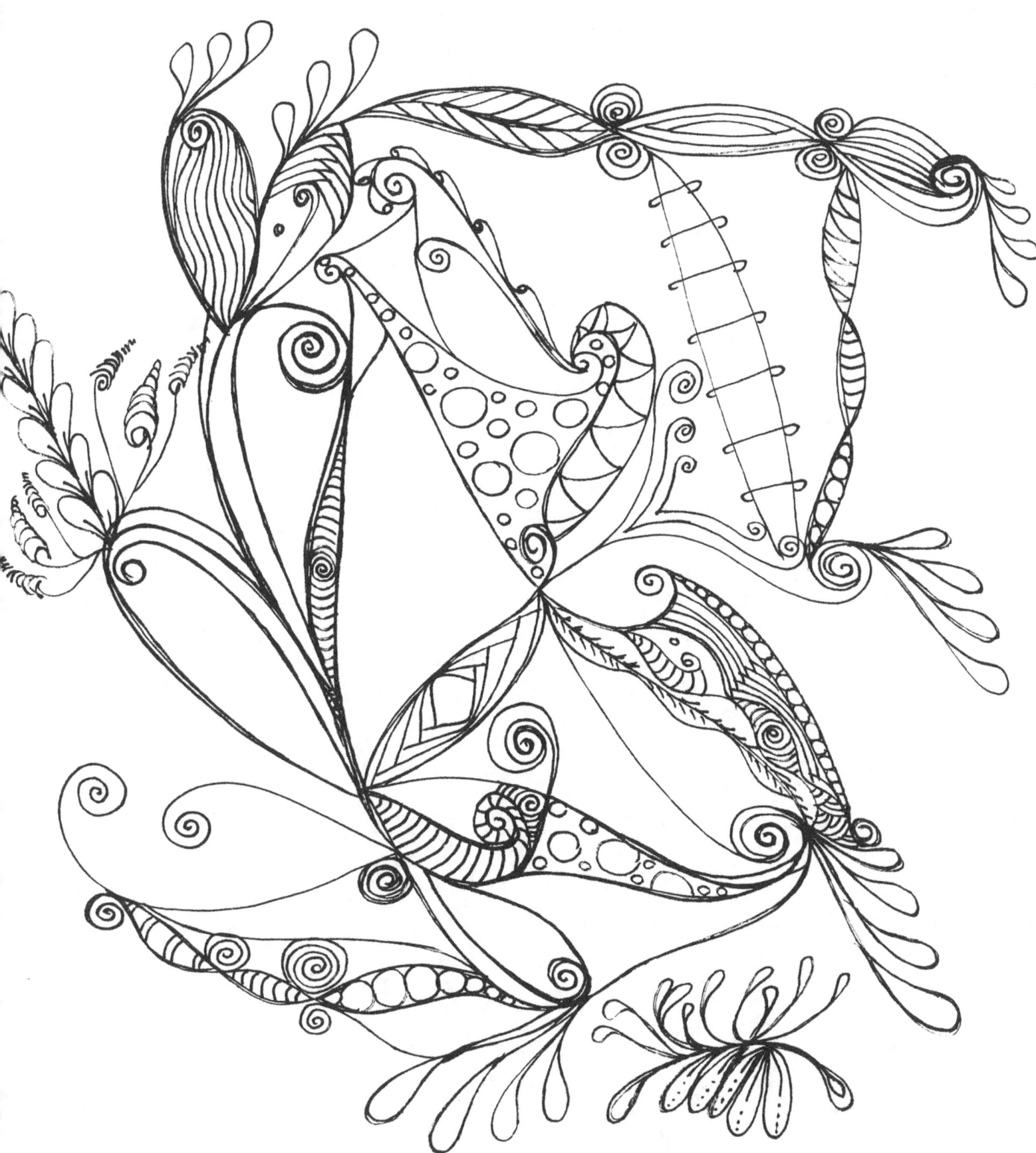

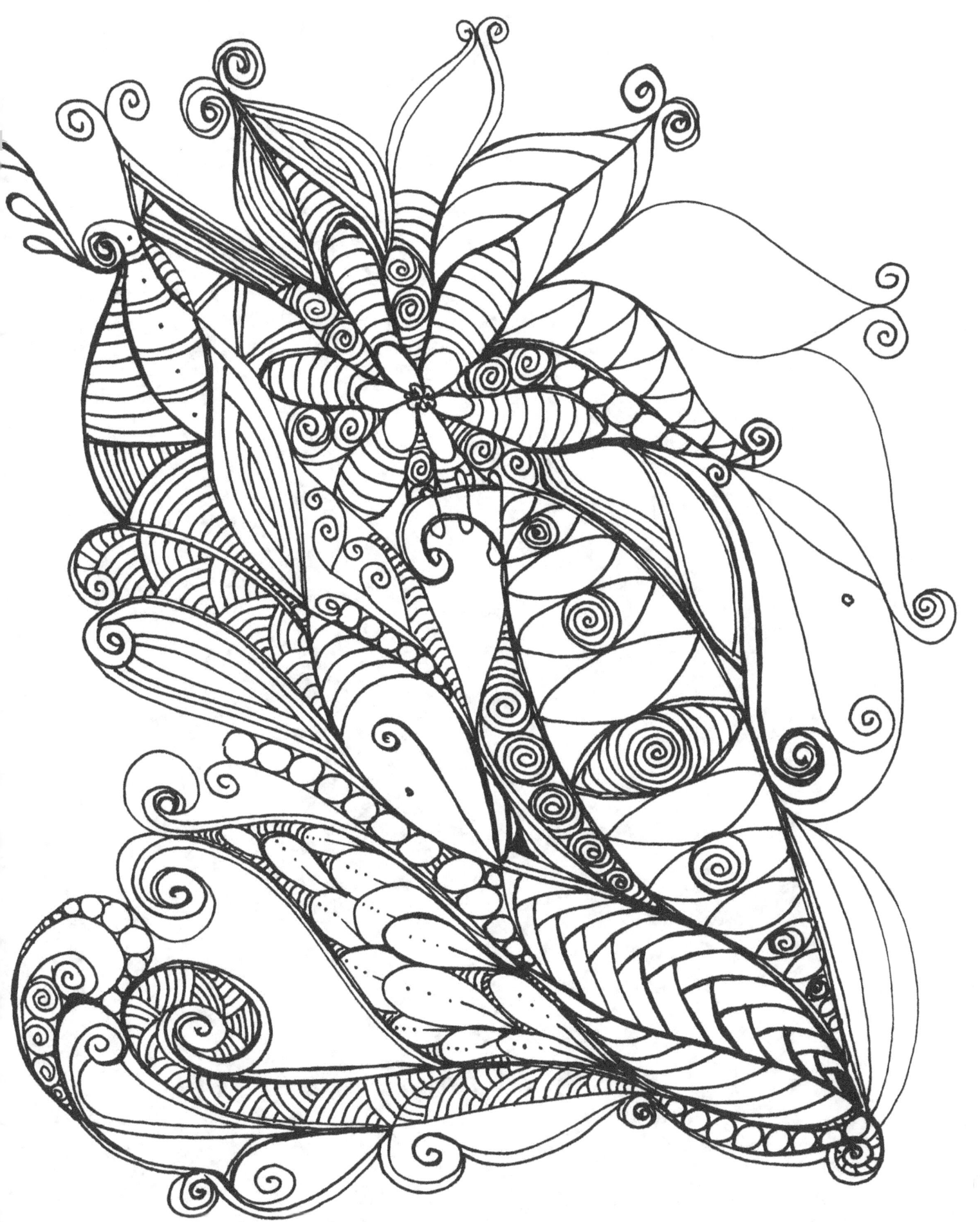

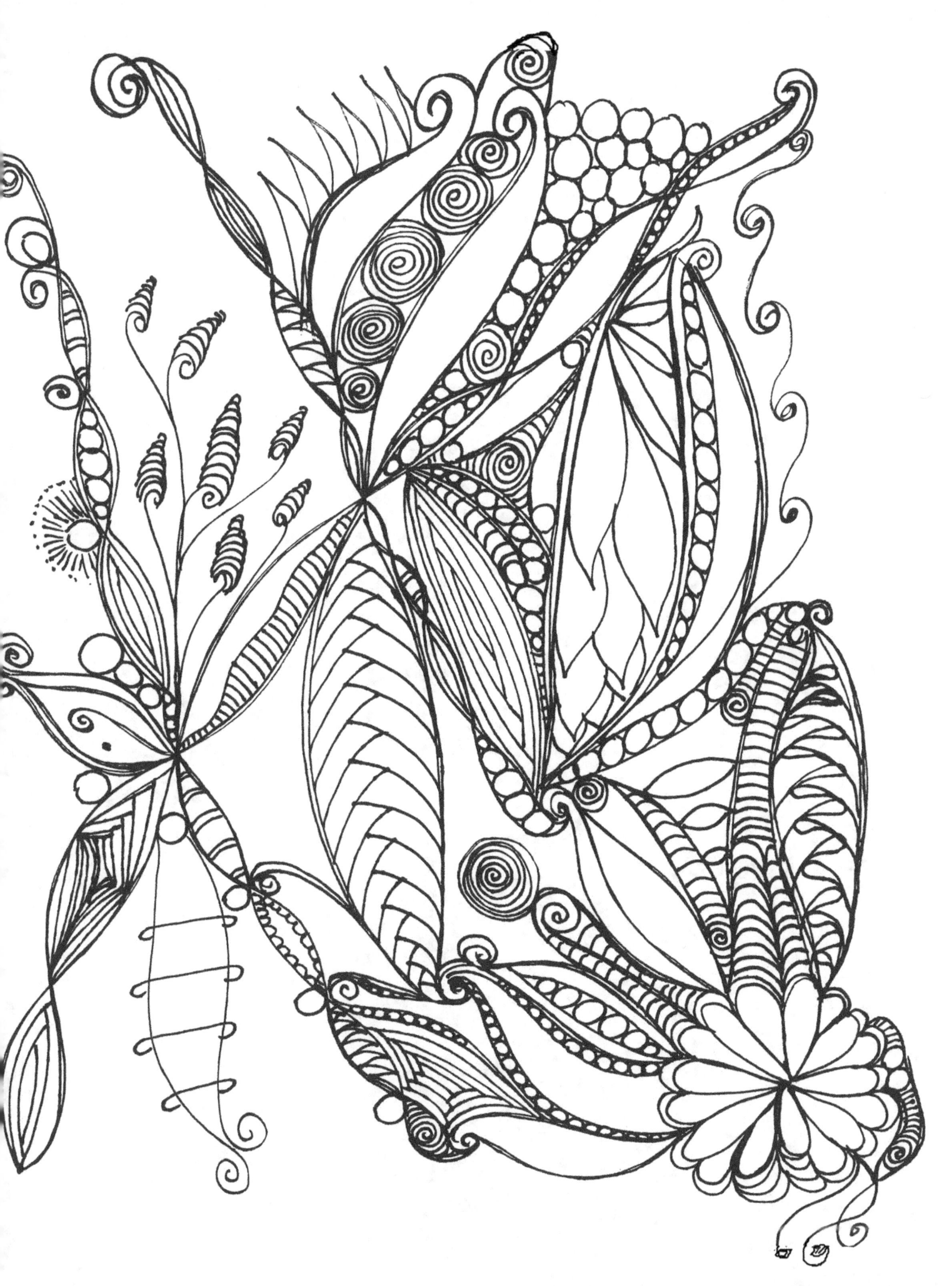

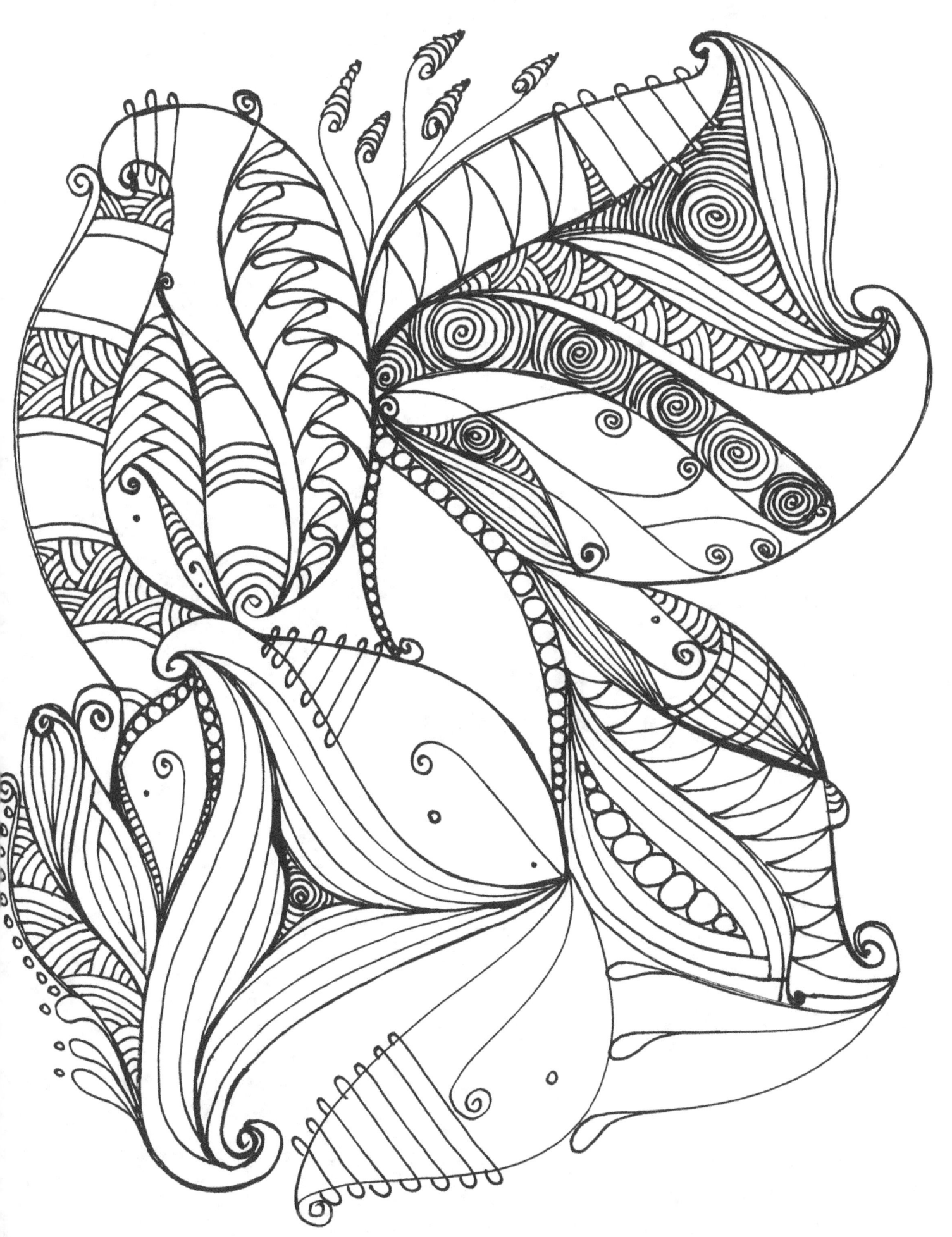

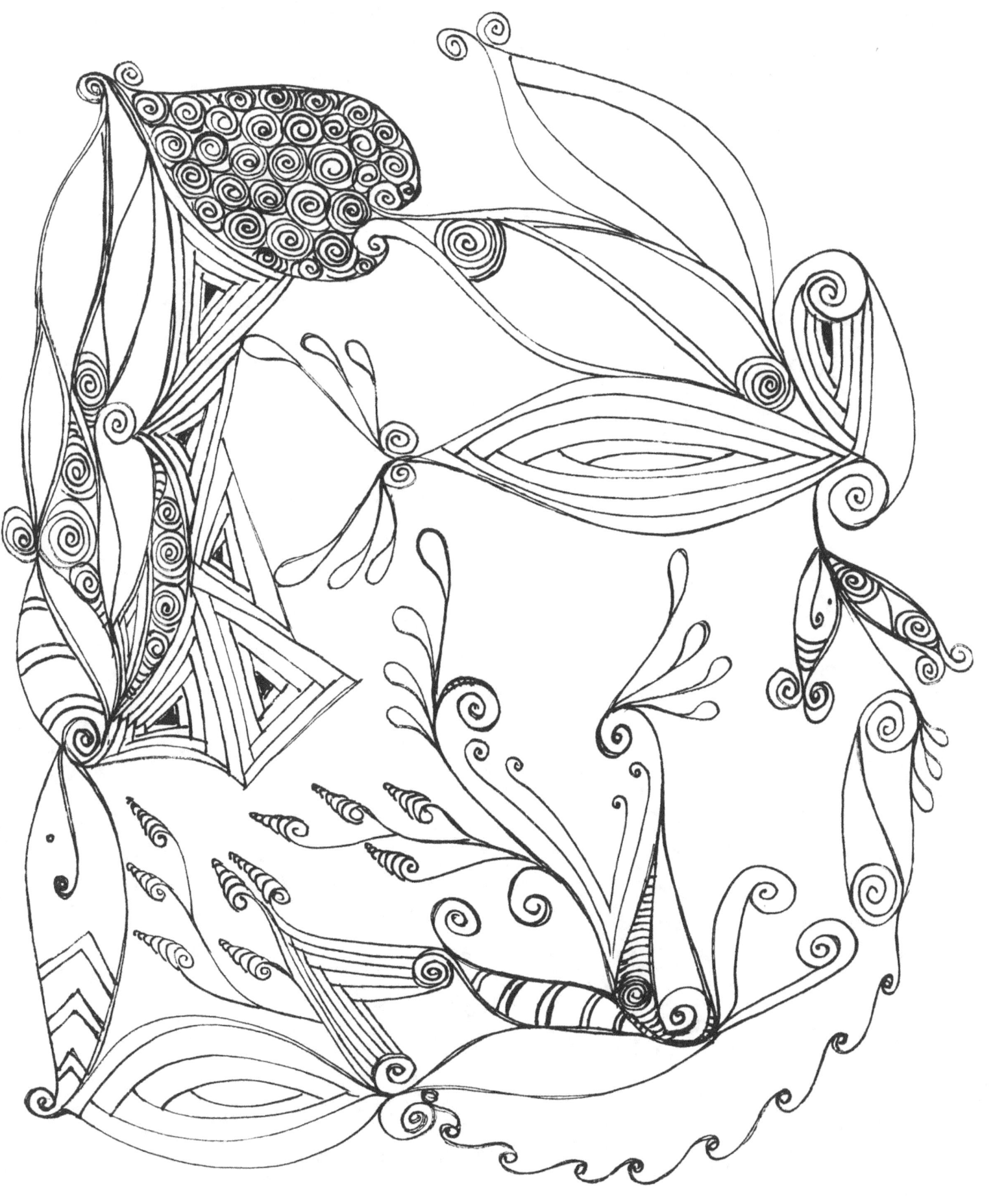

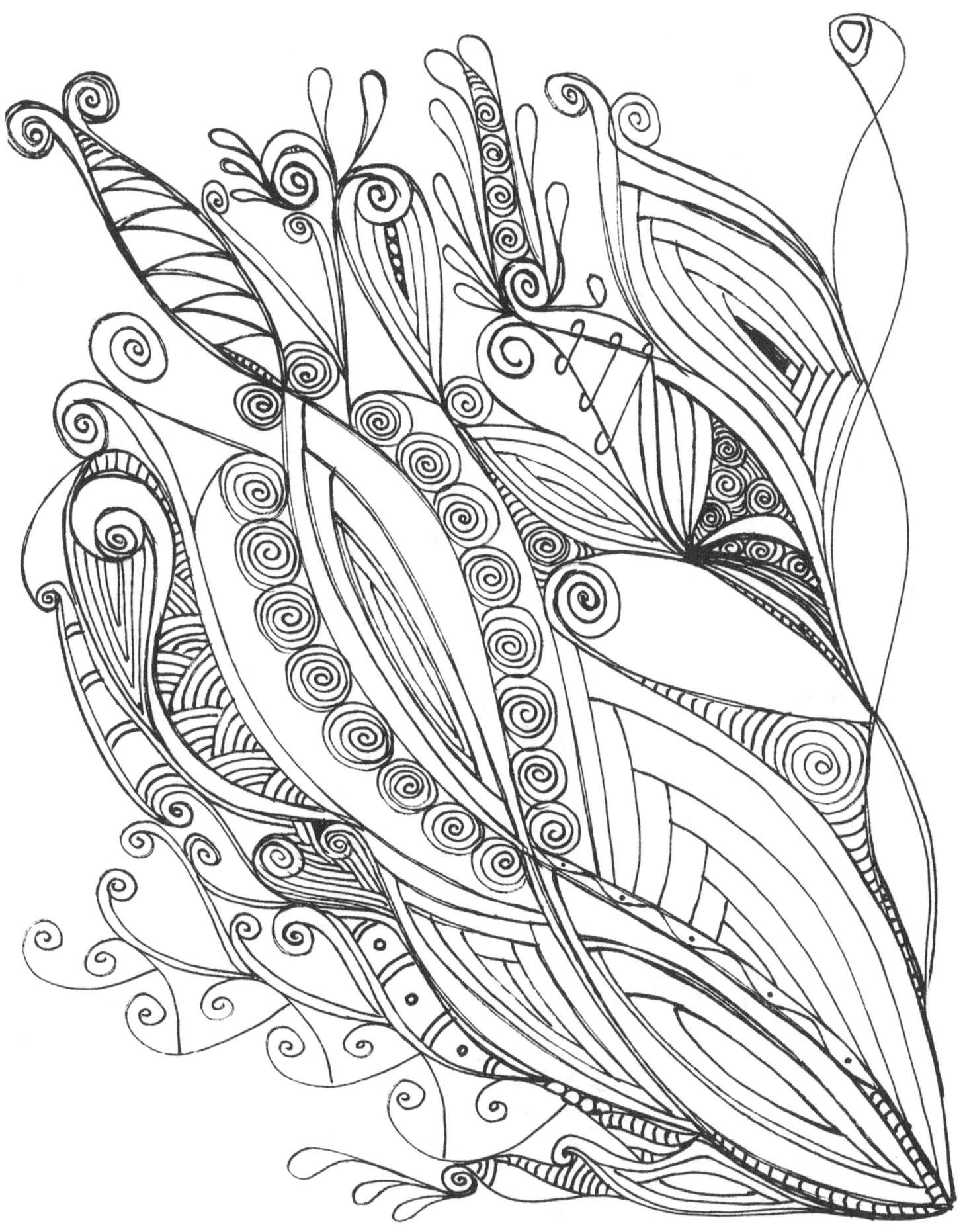

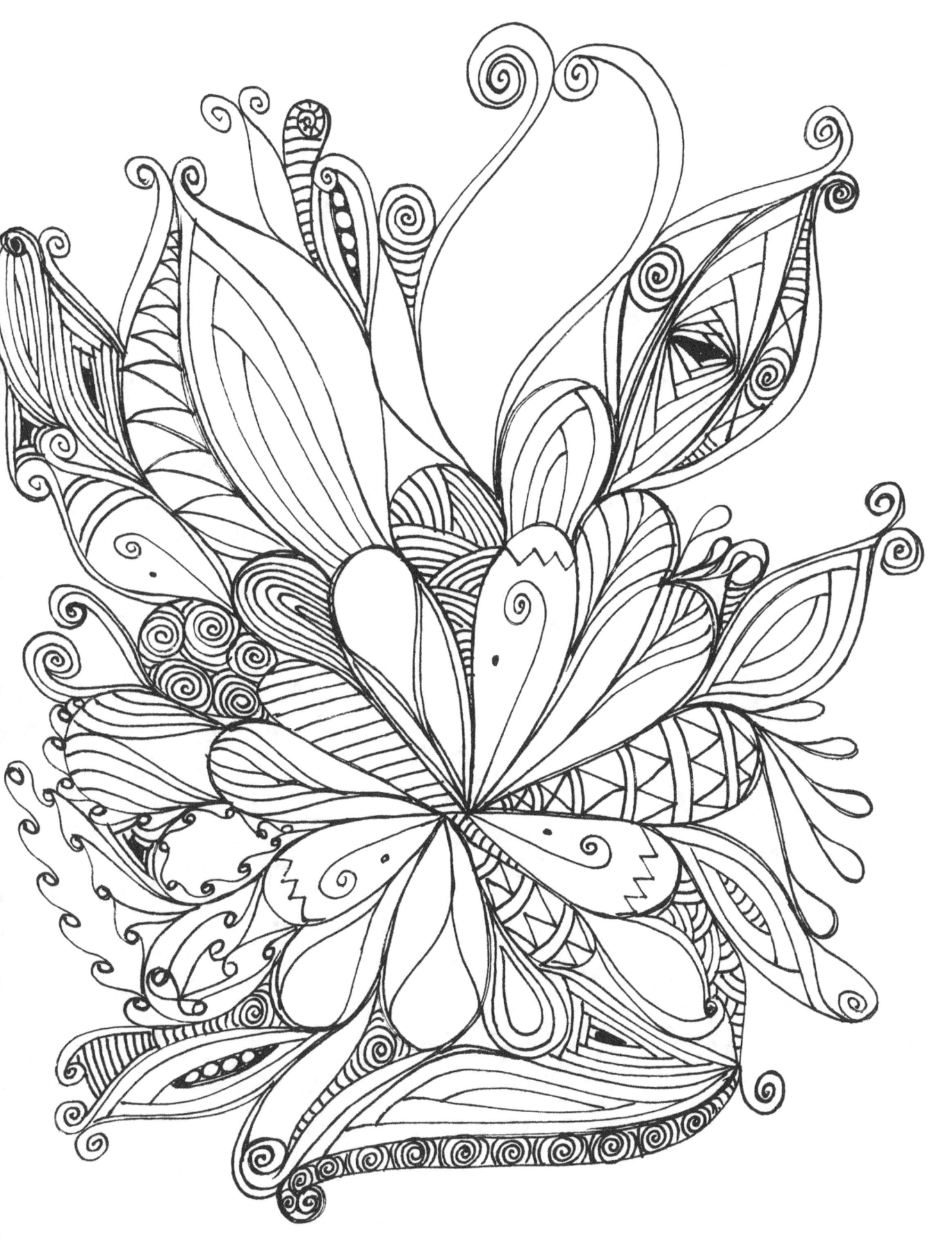

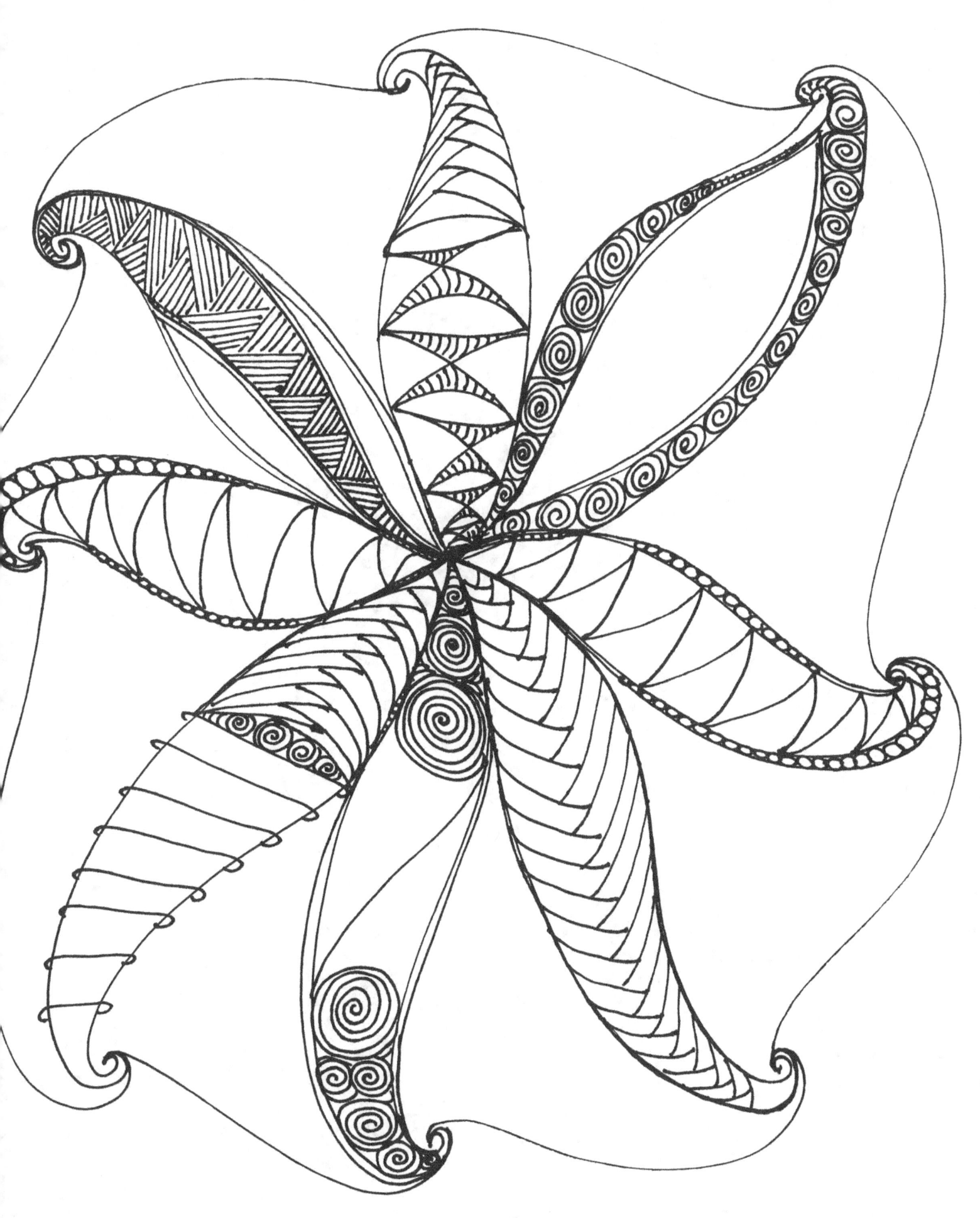

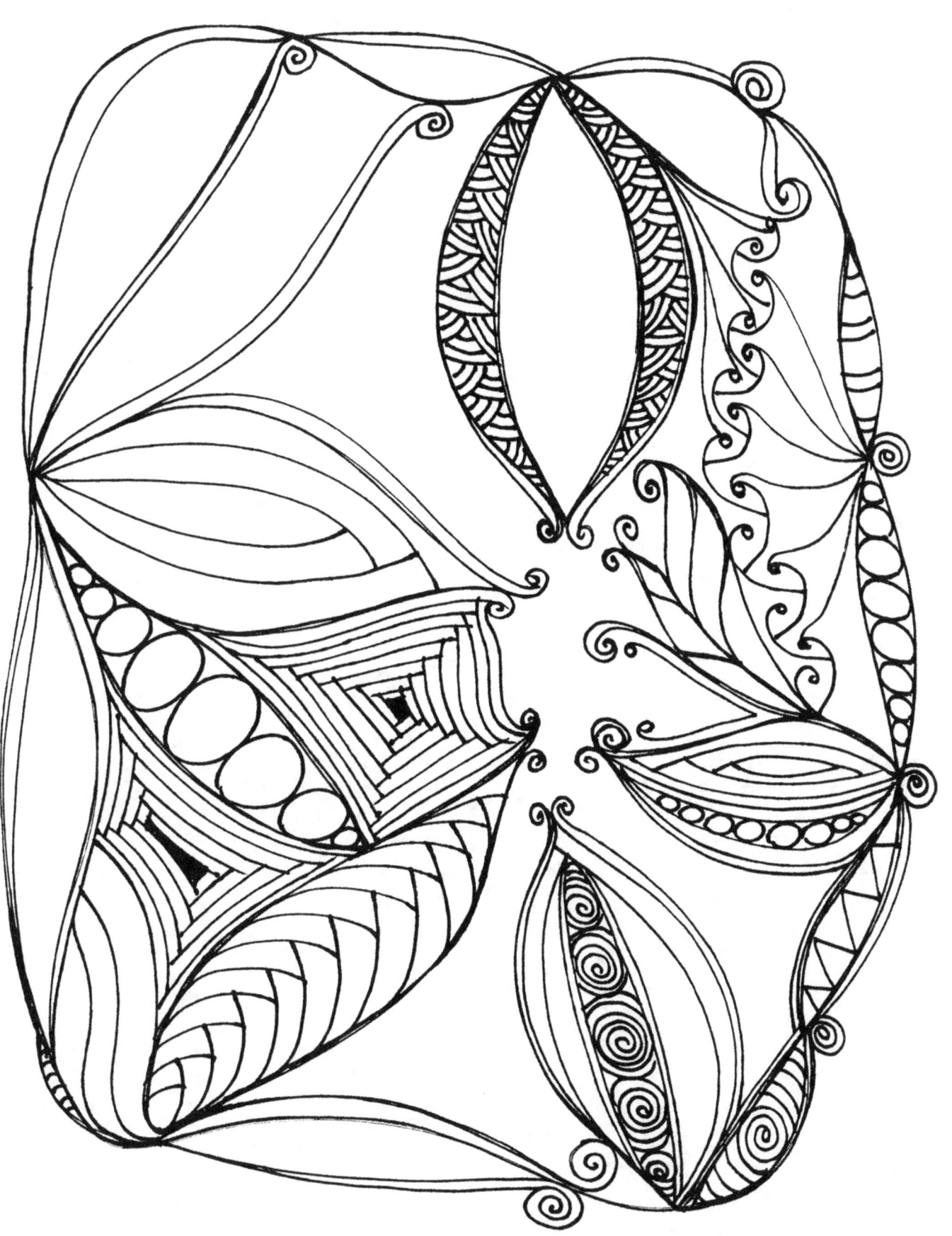

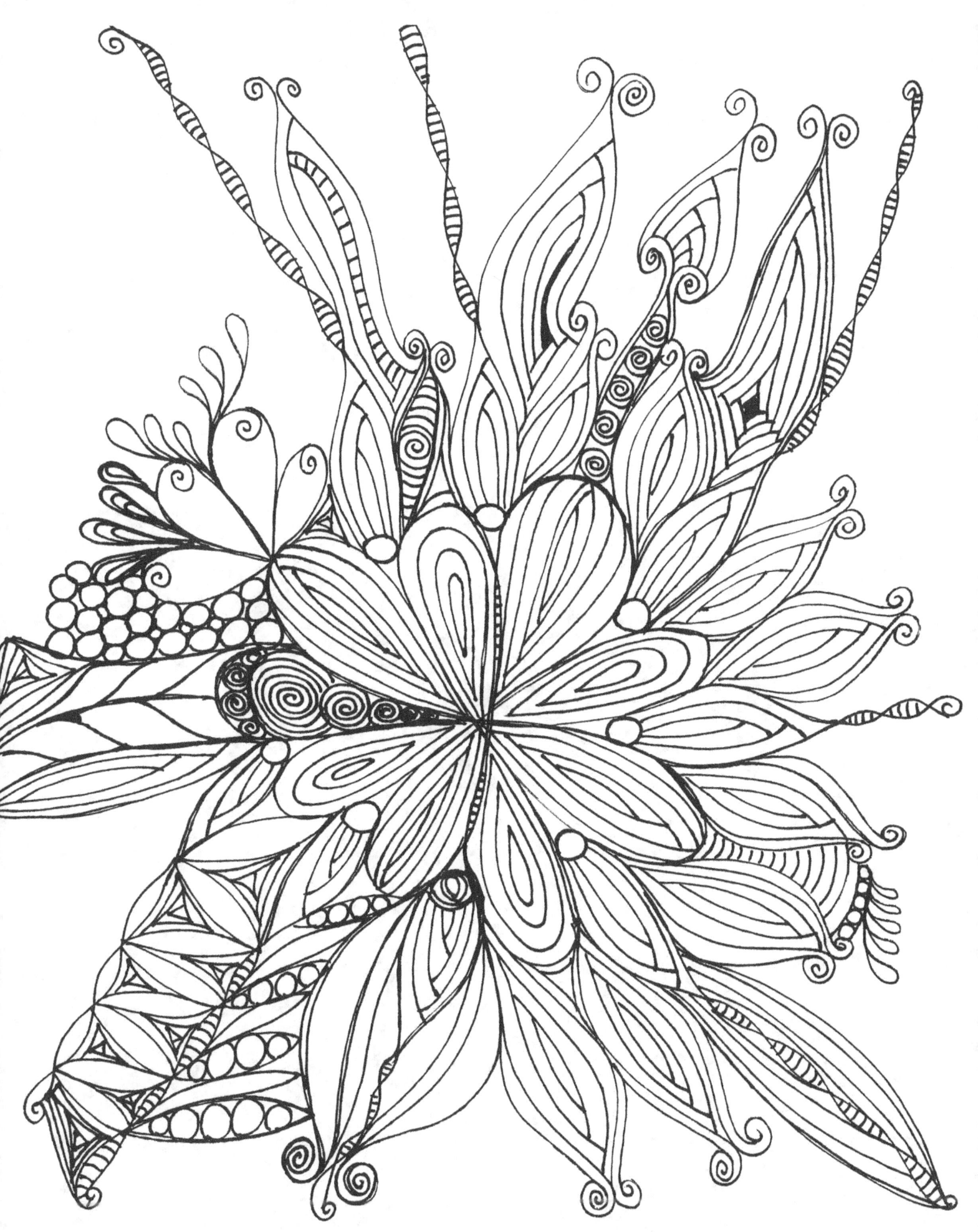

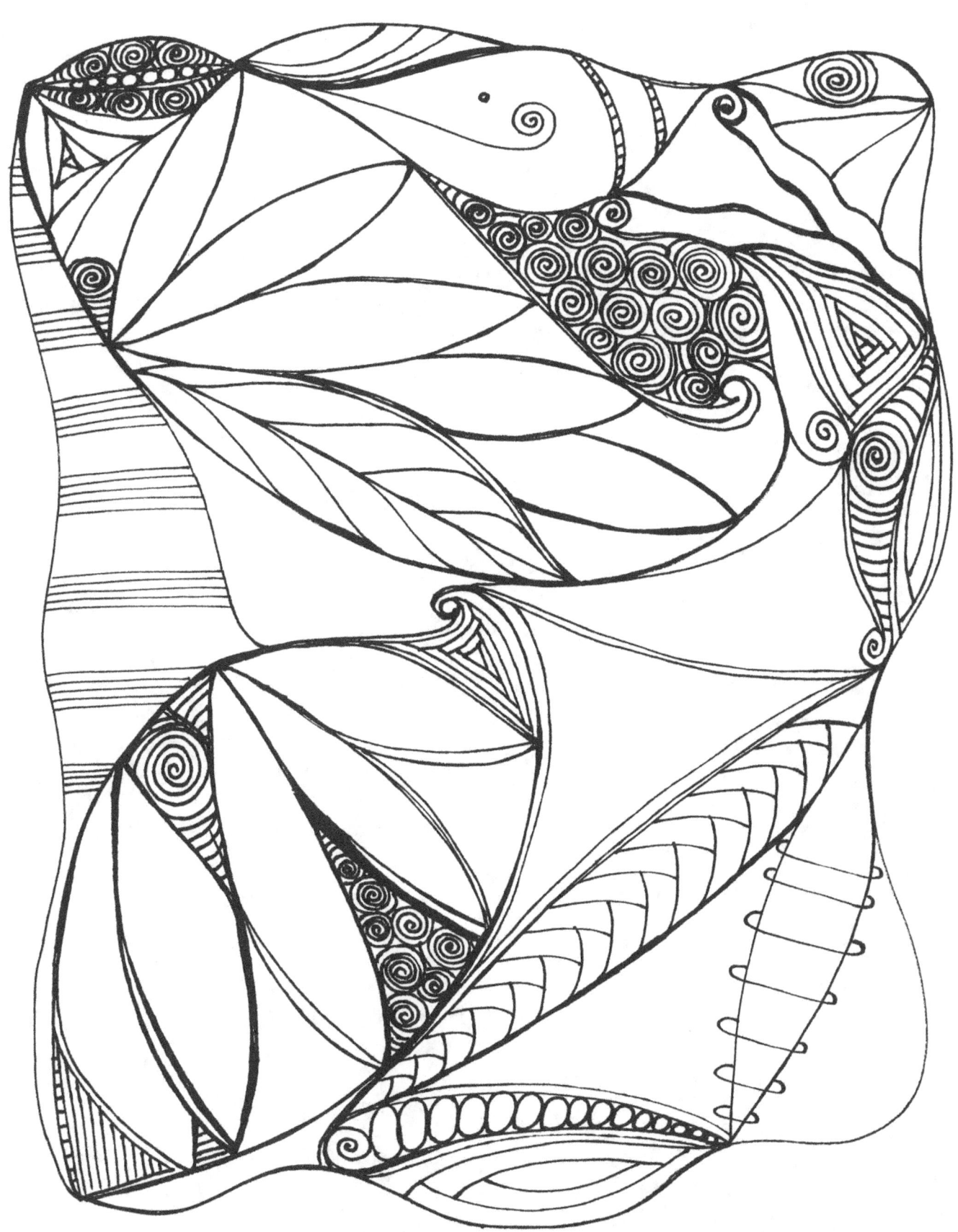

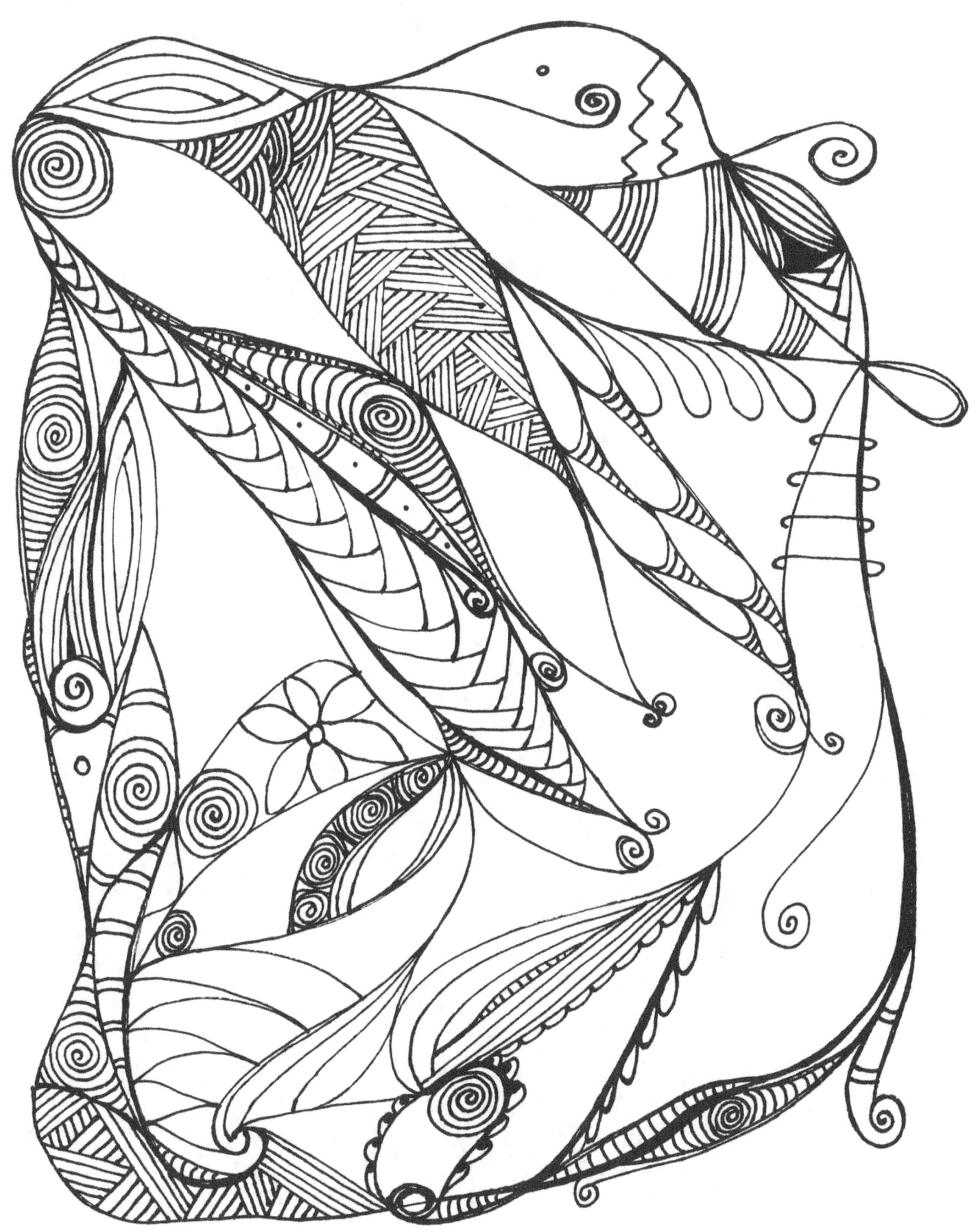

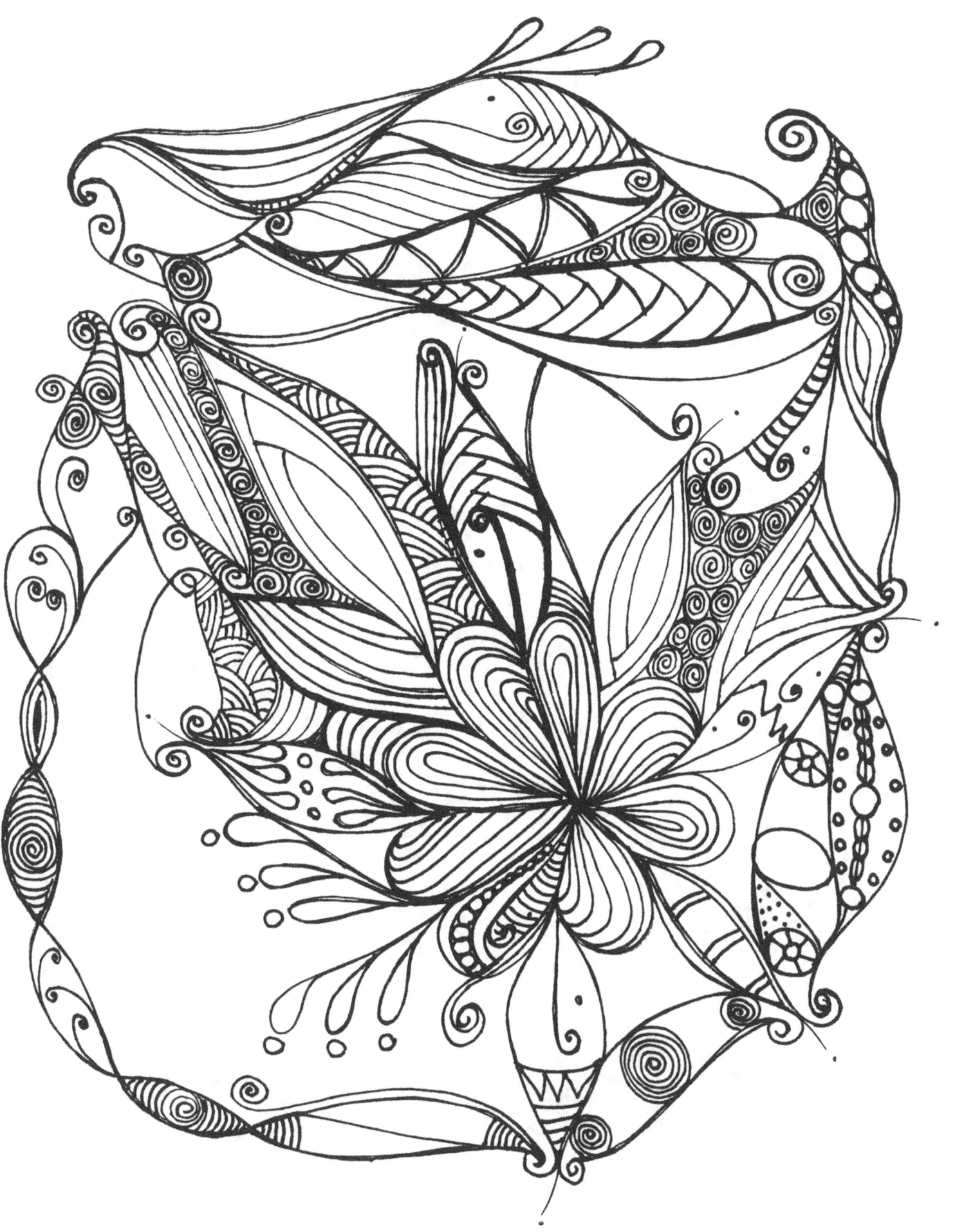

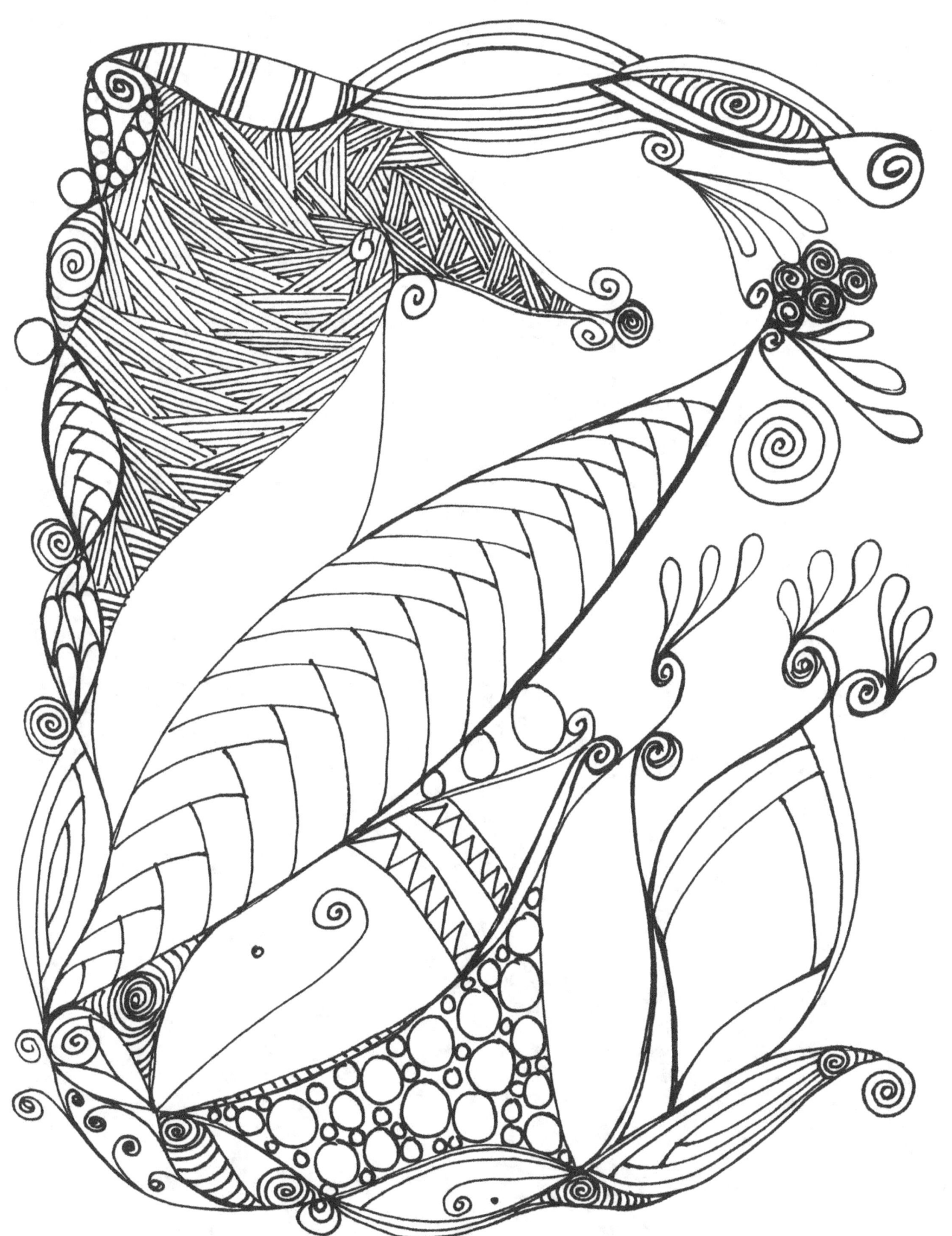

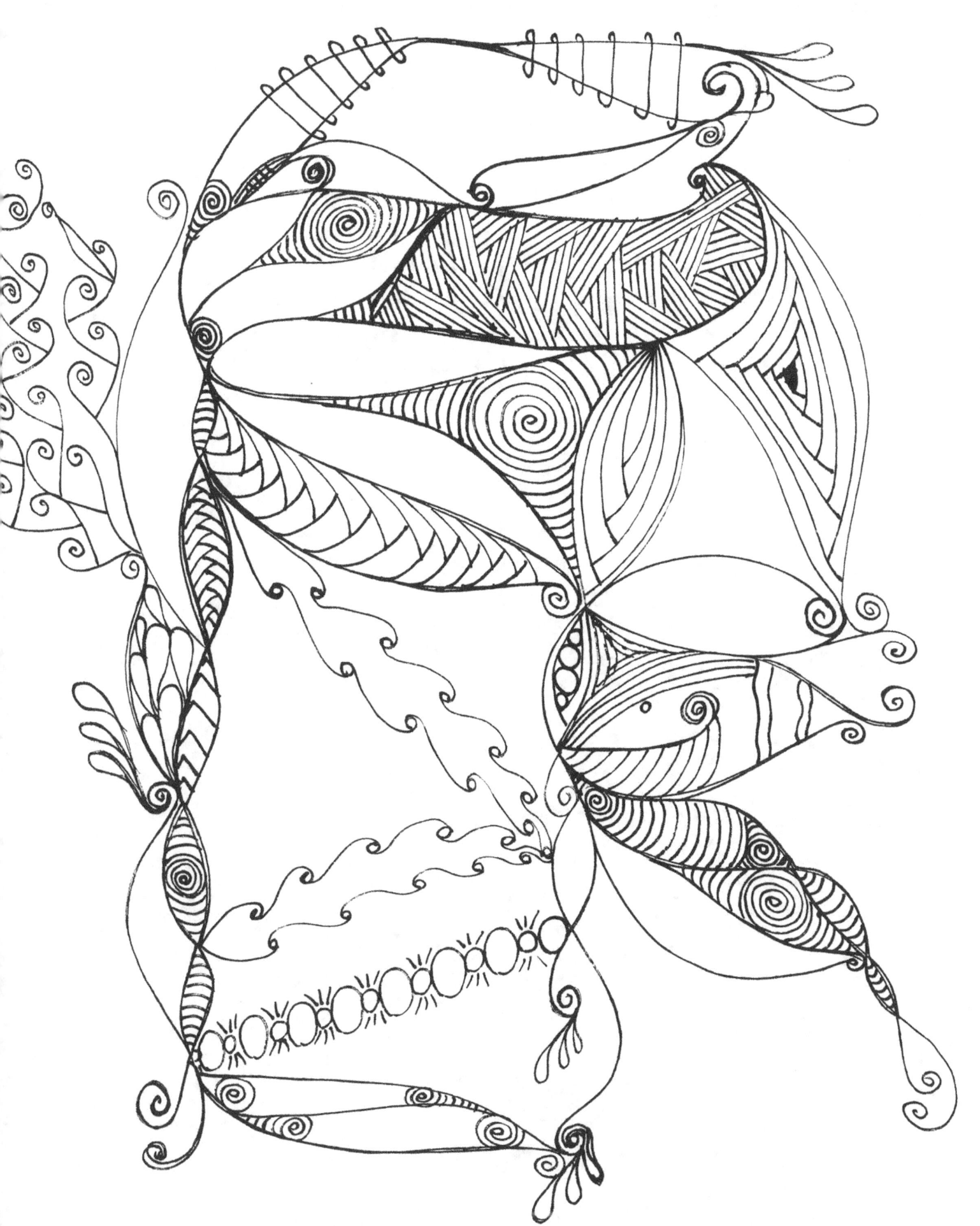

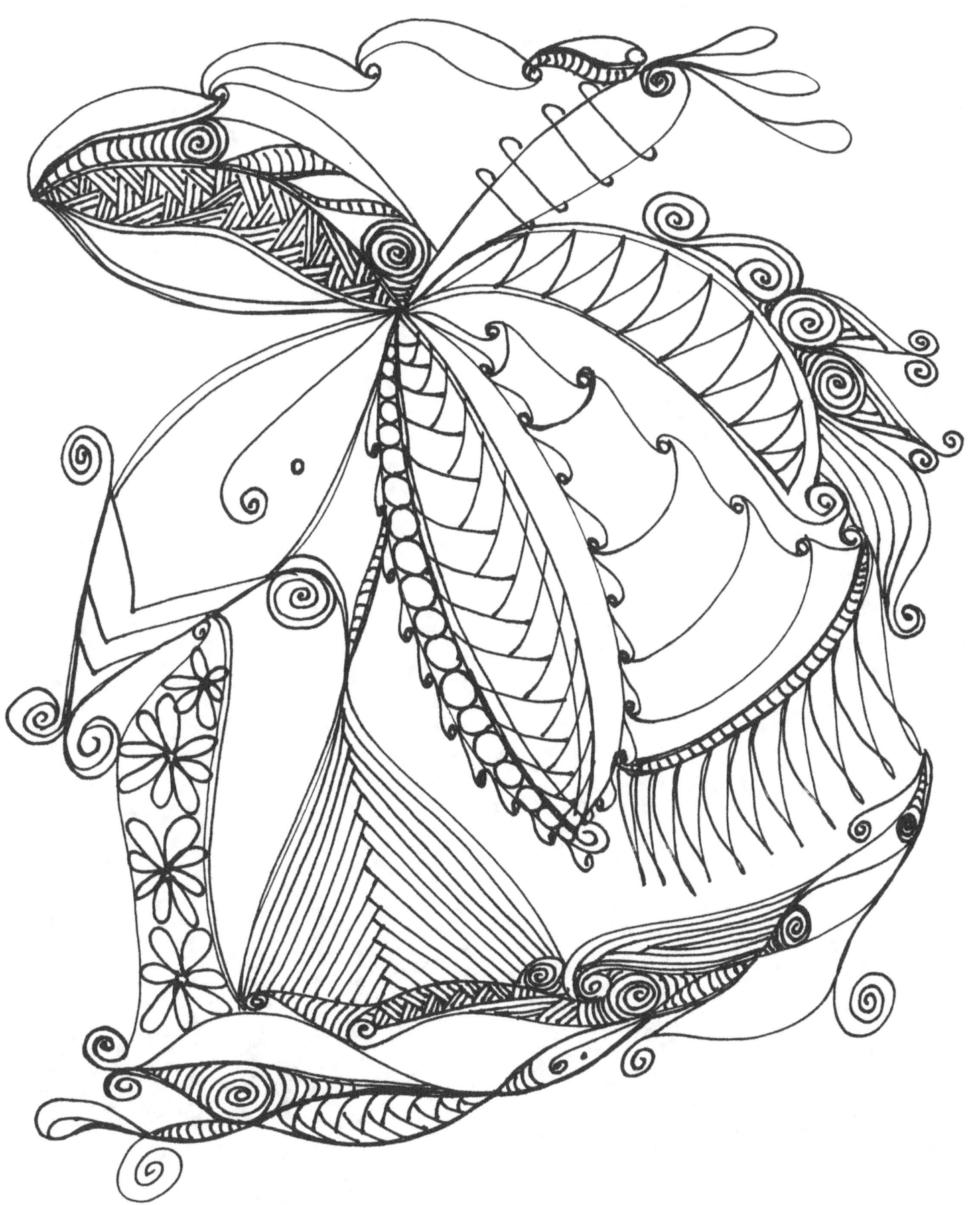

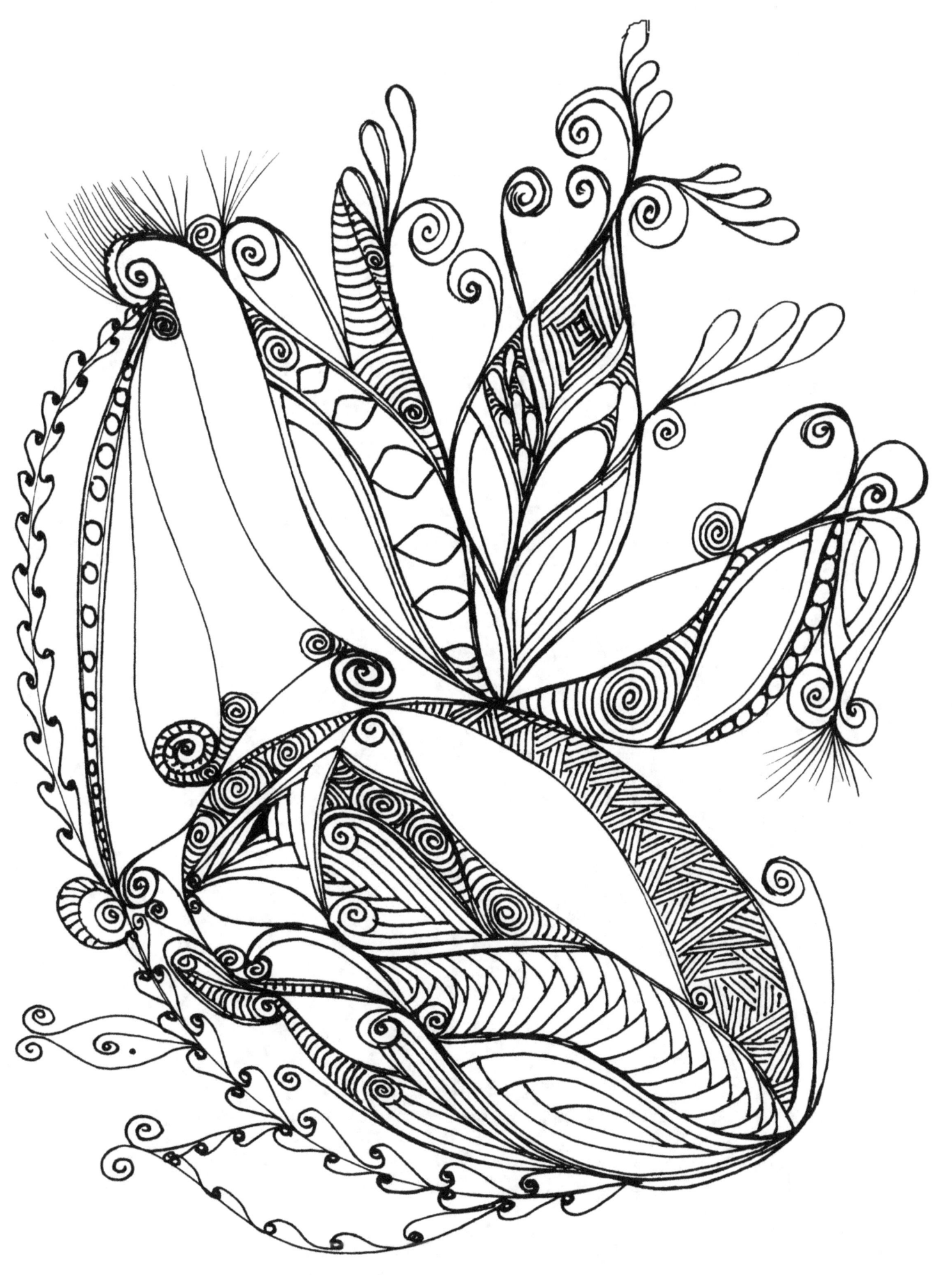

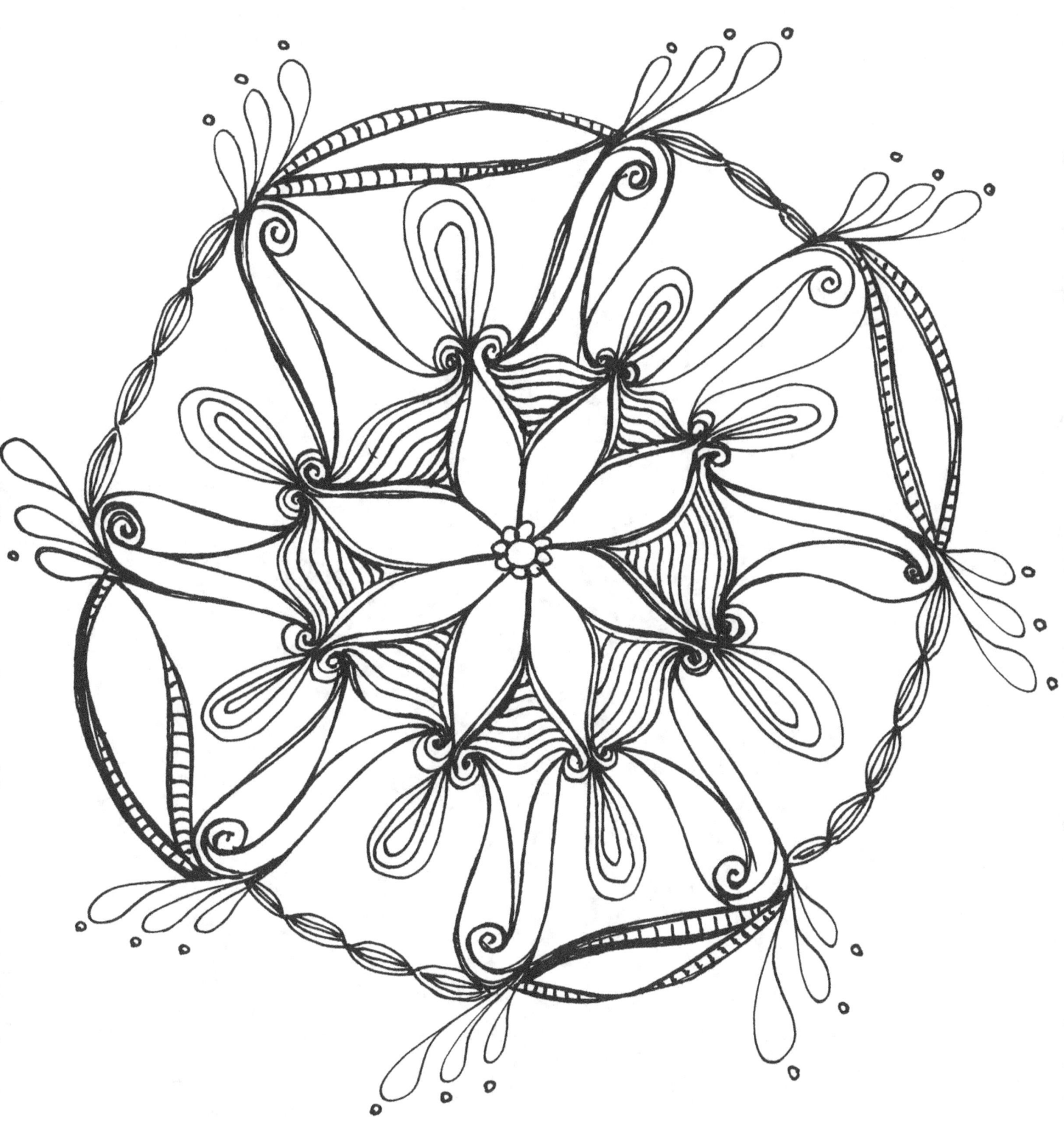

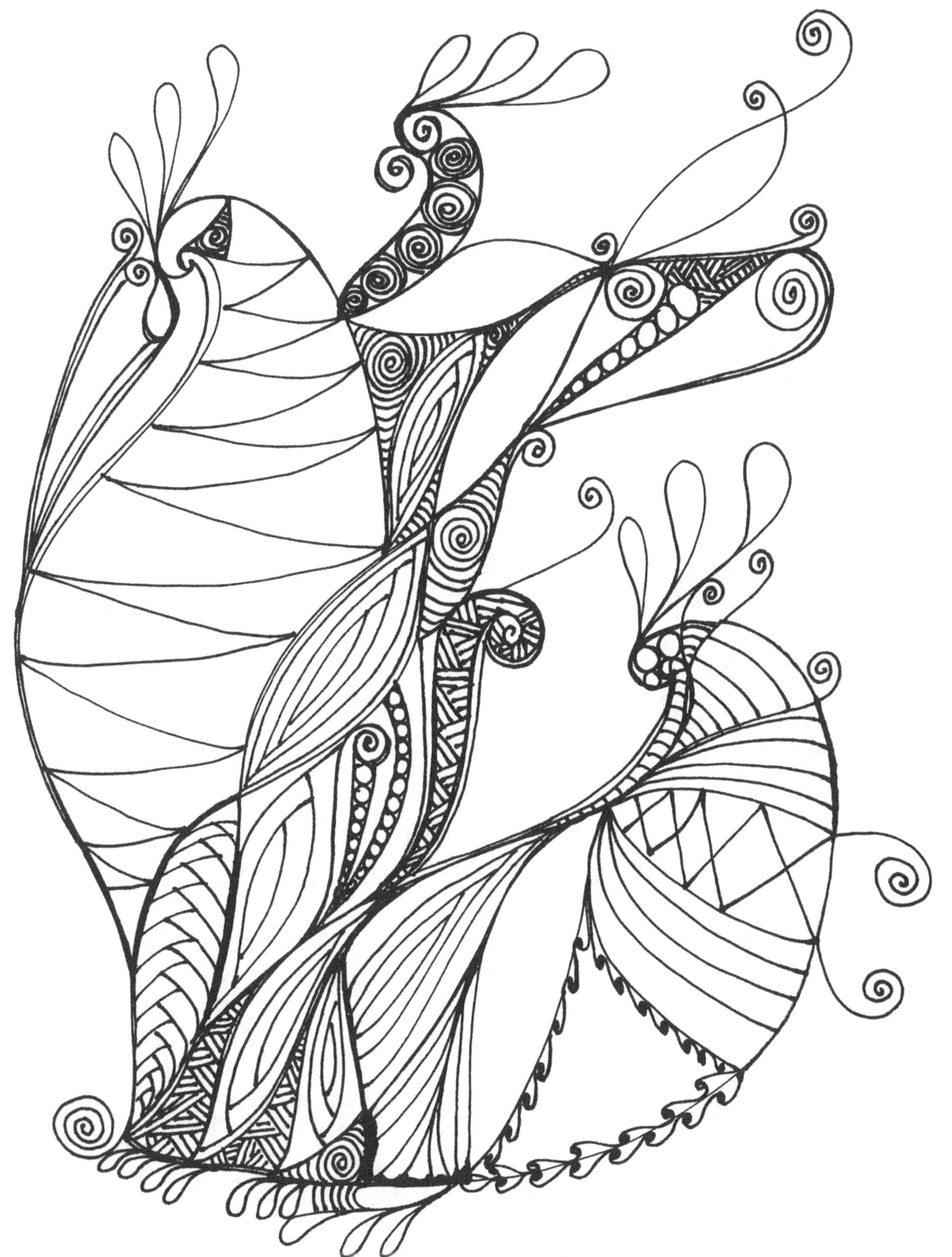

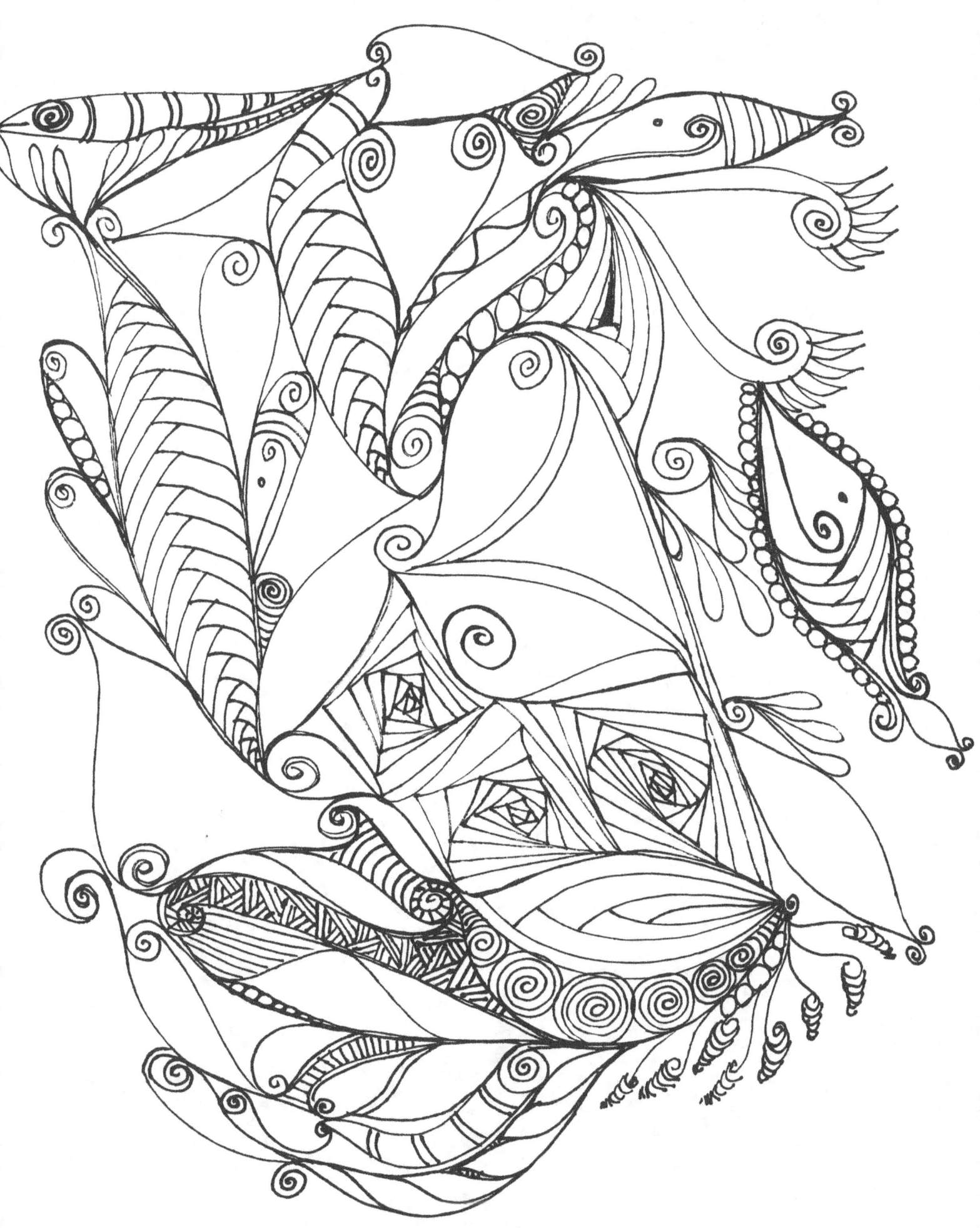

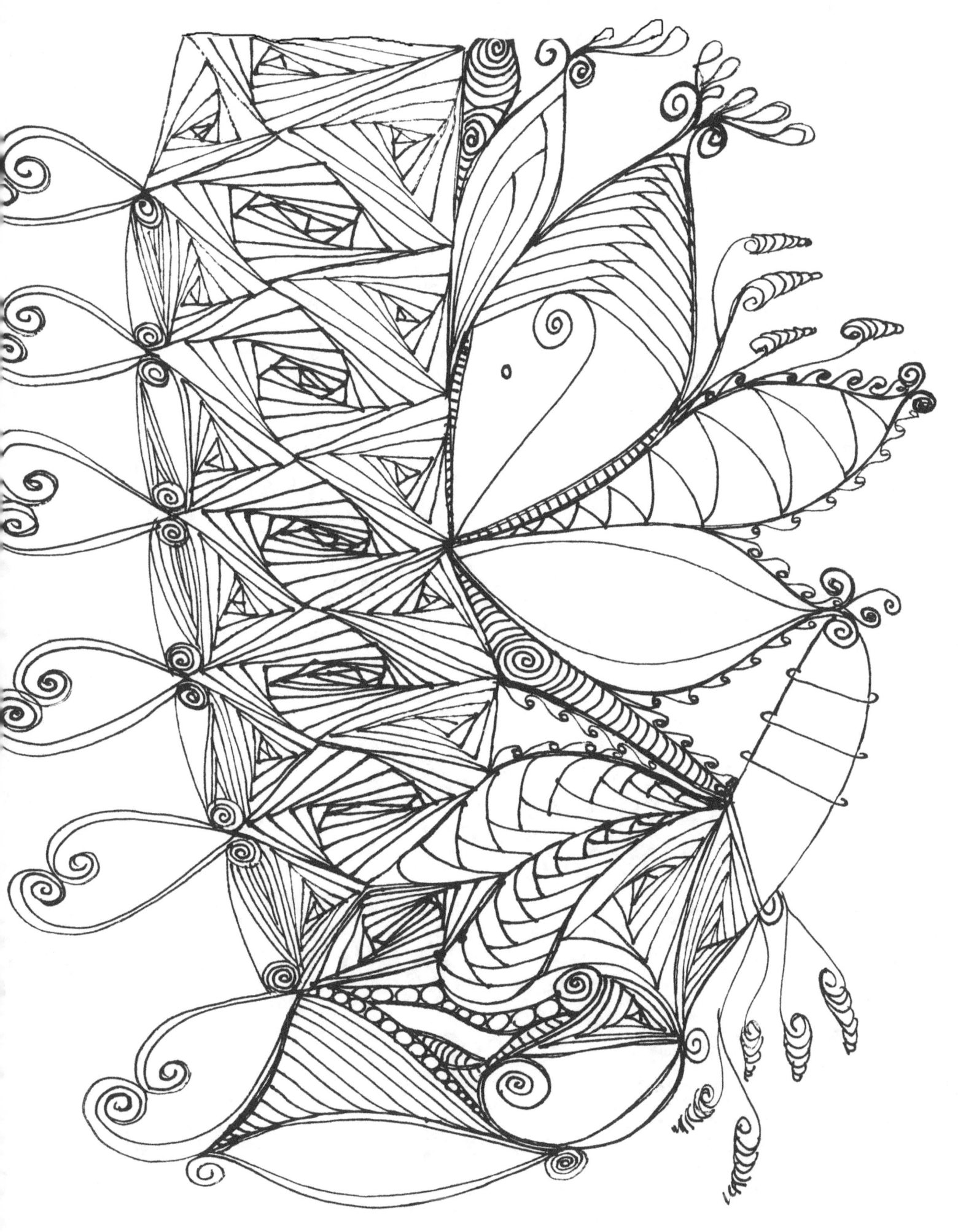

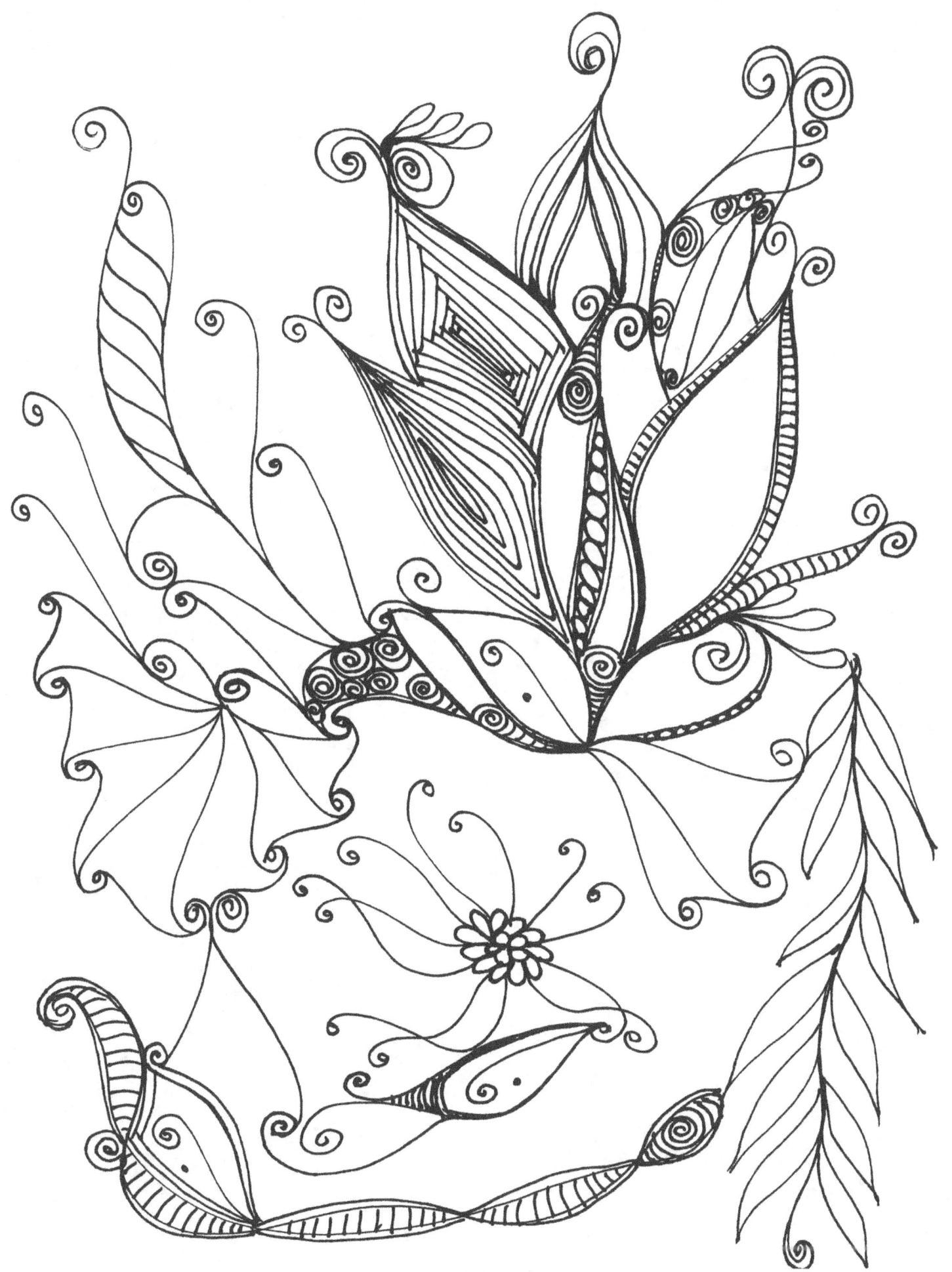

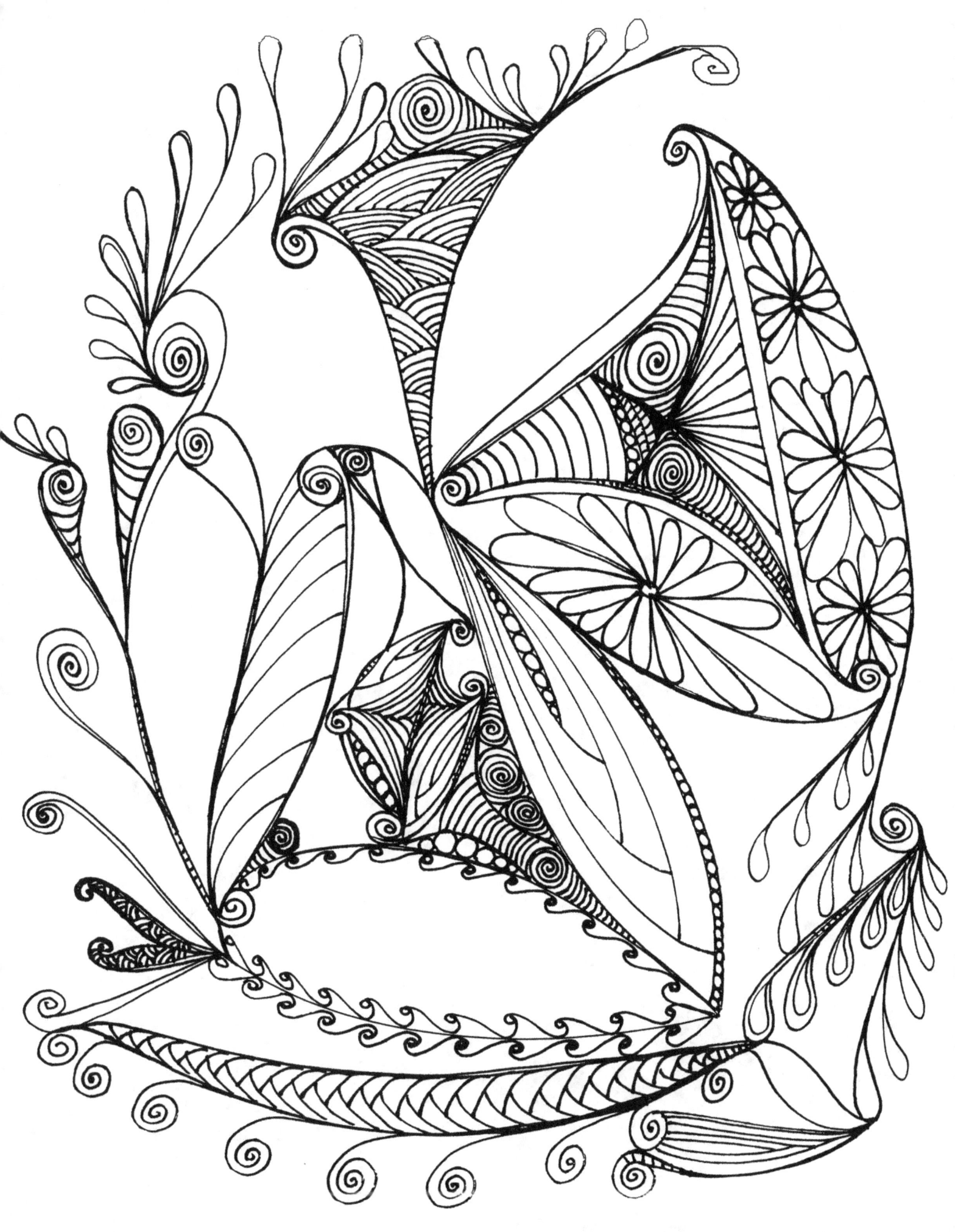

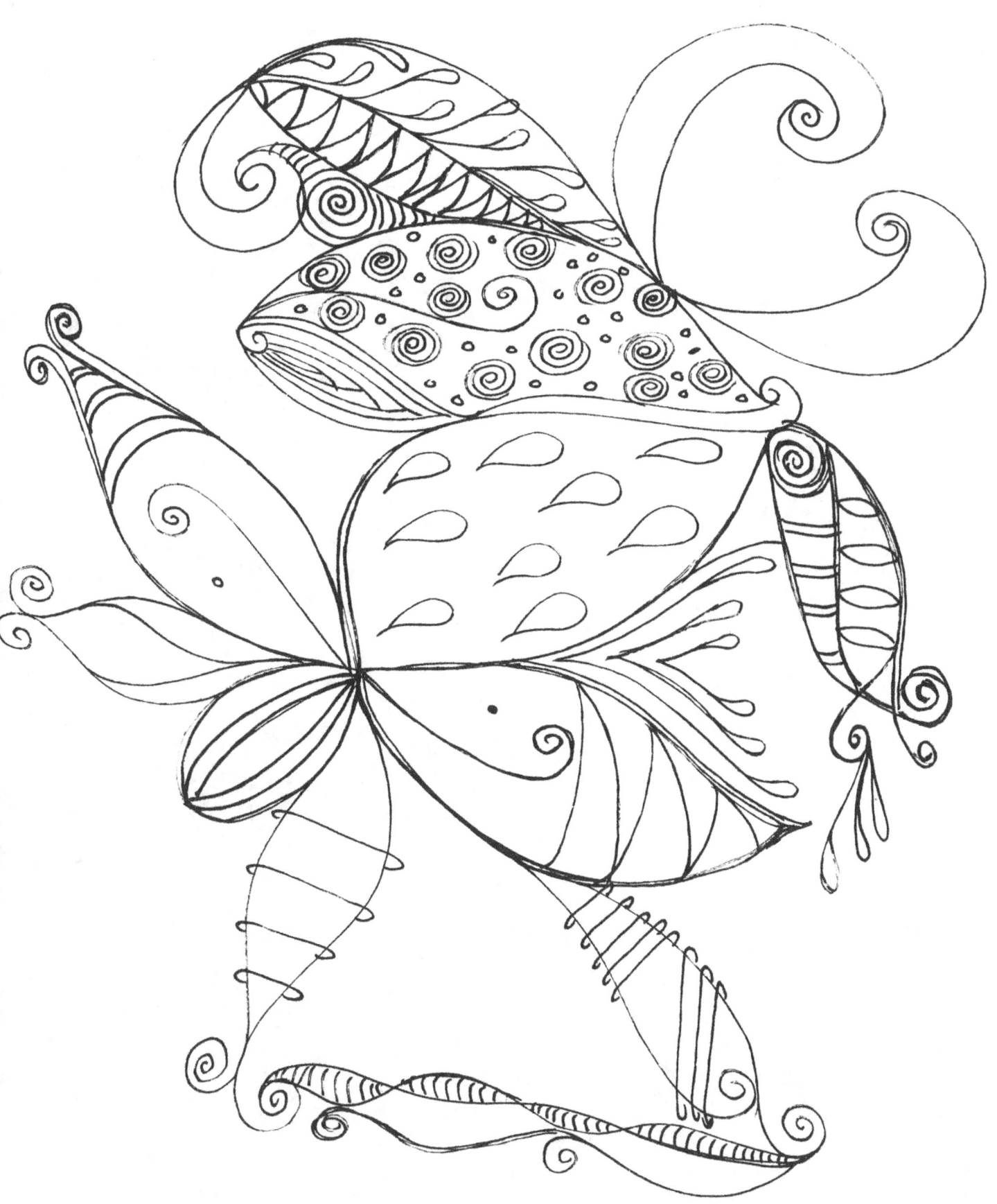

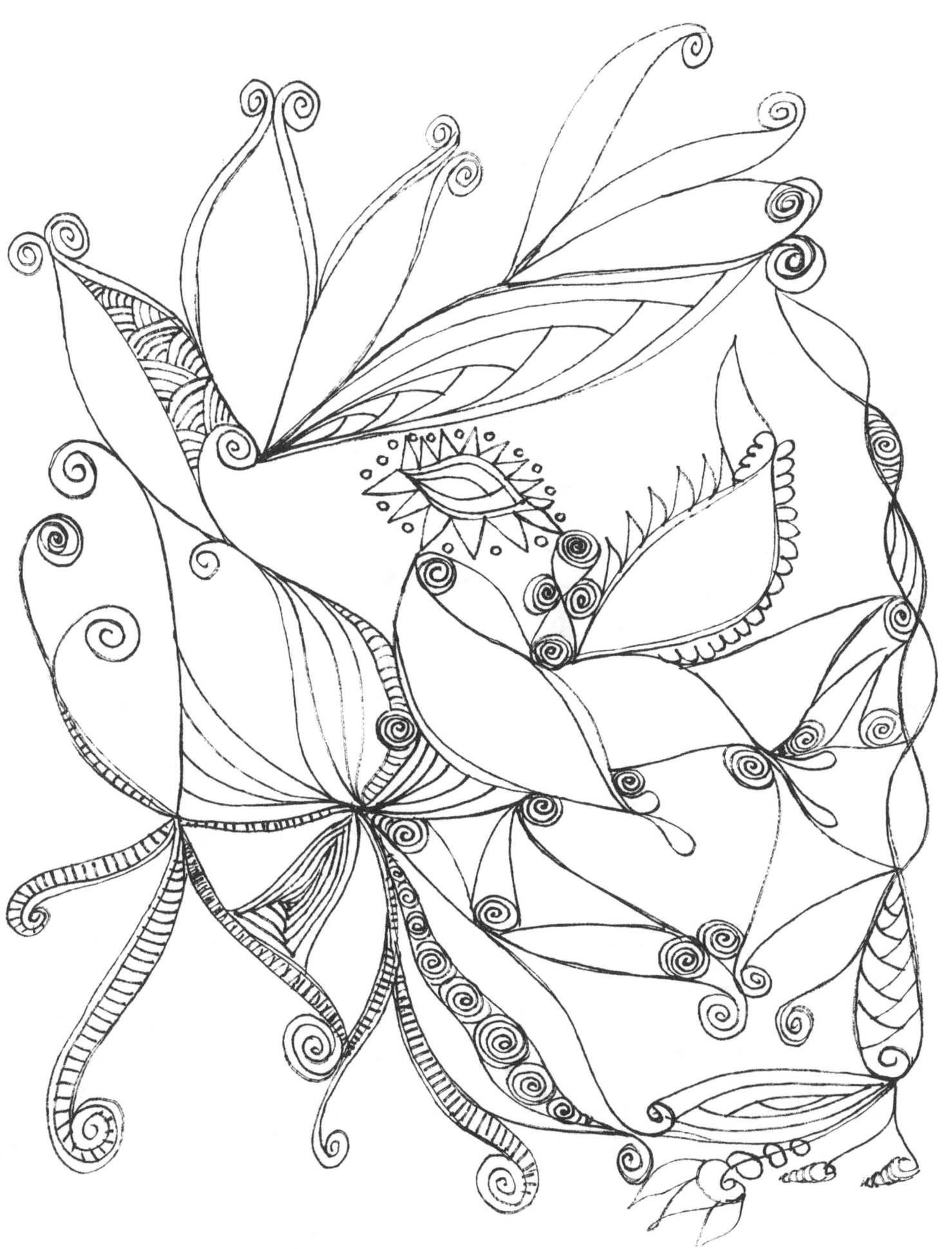

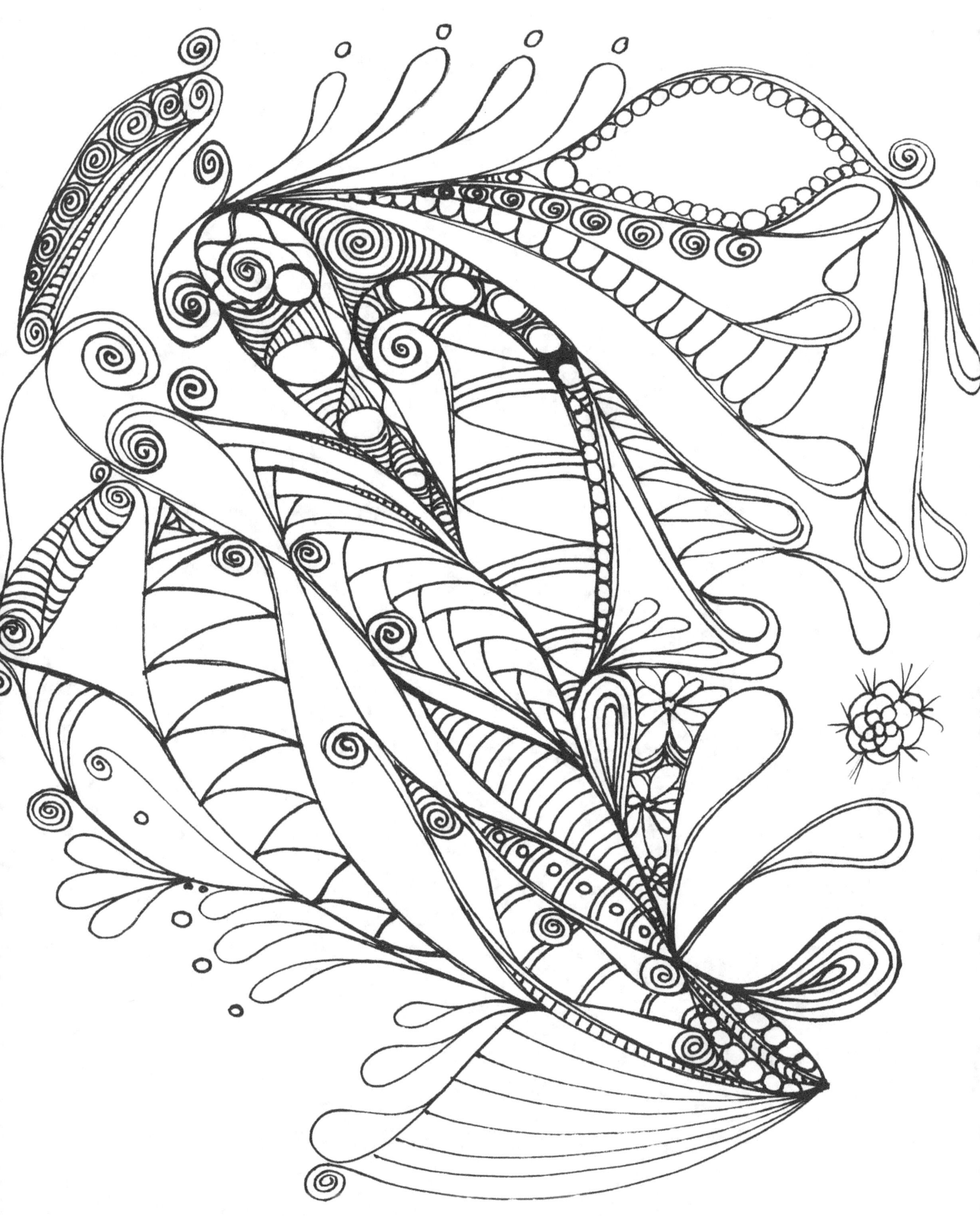

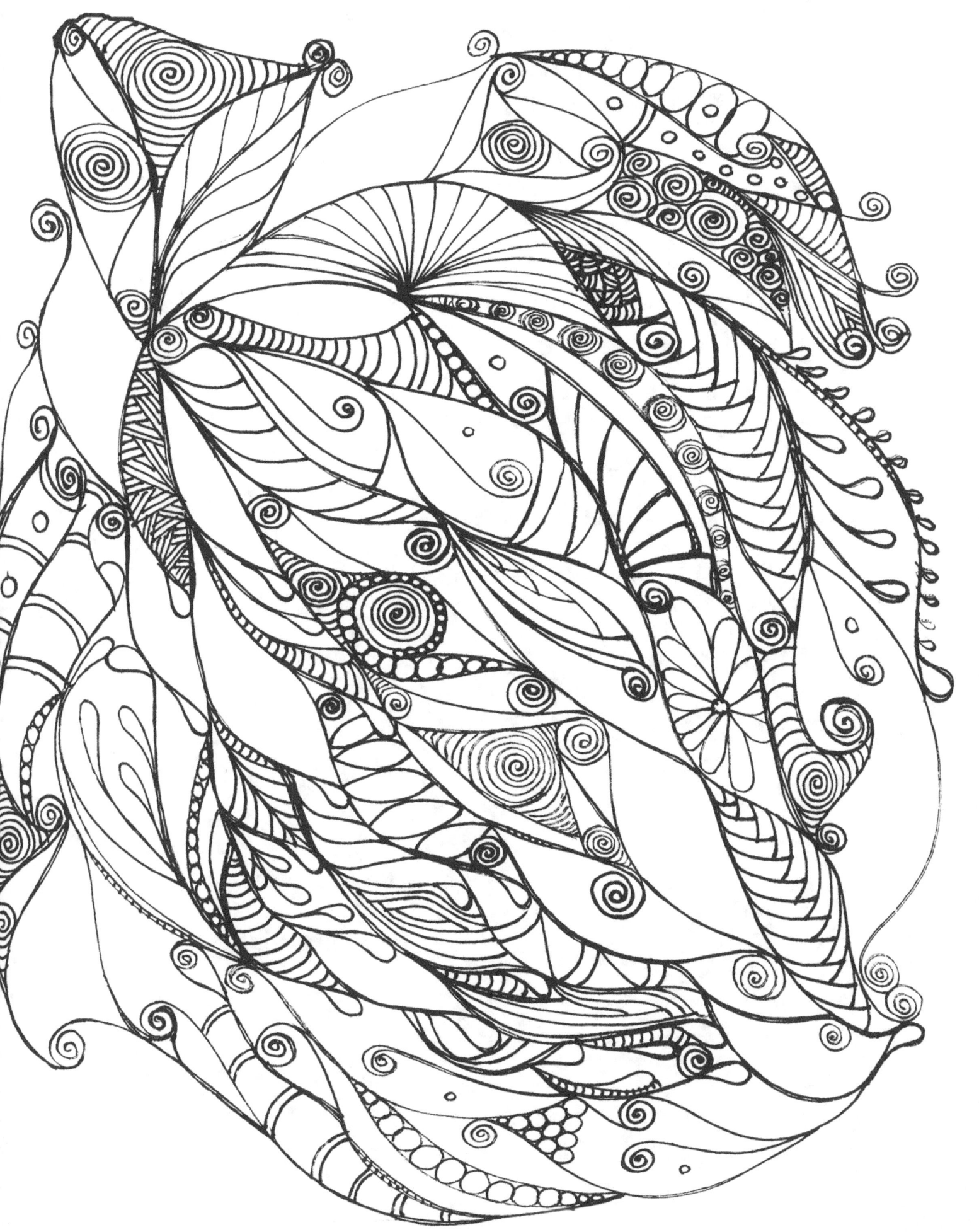

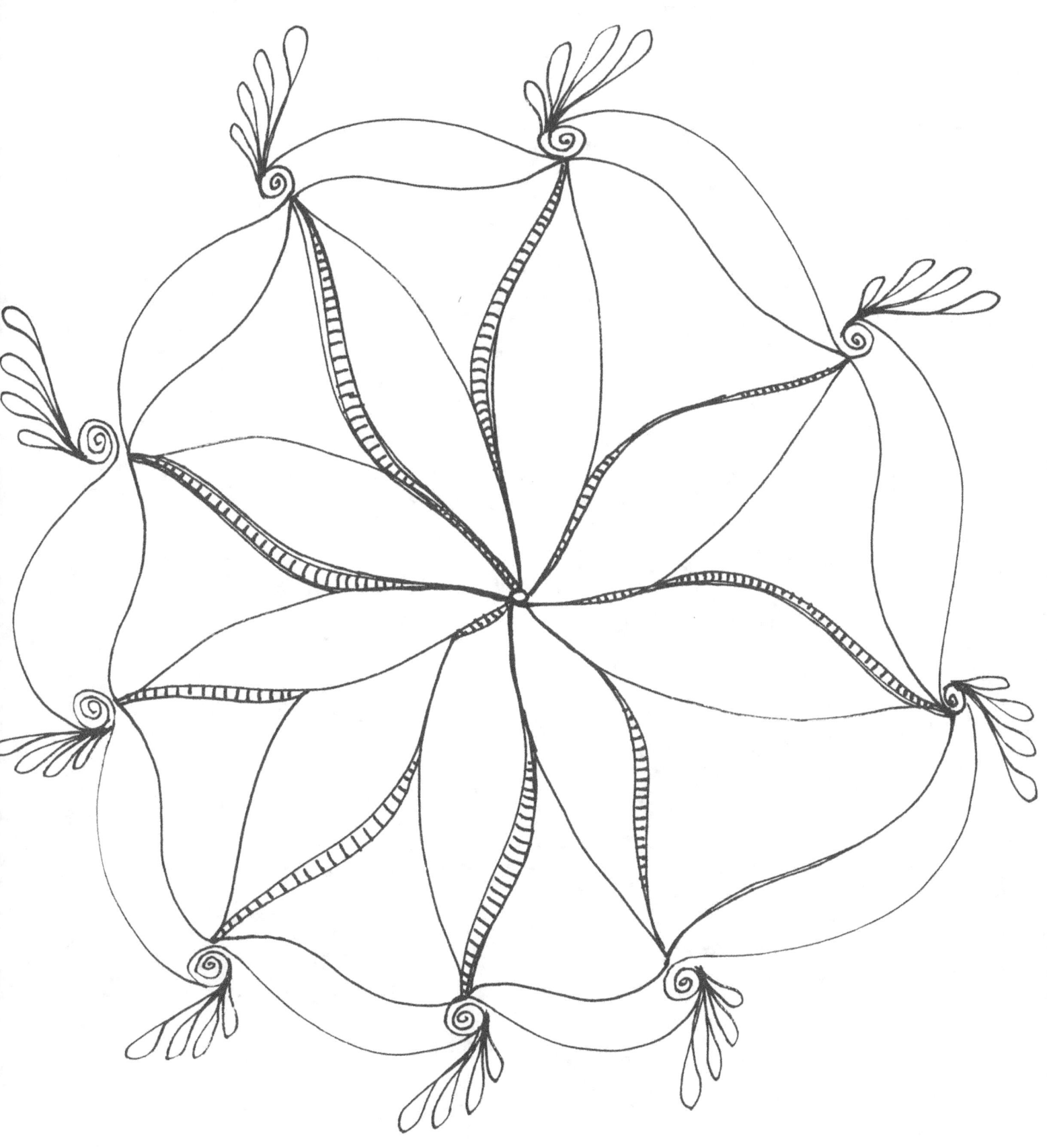

www.ingramcontent.com/pod-product-compliance
Lightning Source LLC
Chambersburg PA
CBHW081256180526
45170CB00007B/2449